THE POSSUM
THAT DIDN'T

THE POSSUM
THAT DIDN'T

Story and Illustrations by
Frank Tashlin

Dover Publications, Inc.
Mineola, New York

Bibliographical Note

This Dover edition, first published in 2016, is an unabridged republication of the
work originally published by Farrar, Straus and Company, New York, in 1950.

Library of Congress Cataloging-in-Publication Data

Names: Tashlin, Frank, author, illustrator.
Title: The possum that didn't / story and illustrations by Frank Tashlin.
Other titles: Possum that did not
Description: Mineola, New York : Dover Publications, 2016. | Summary: There
 was a little possum who wore a big smile, content to hang by his tail from
 a tree until one day he was discovered by a group of picnickers who
 mistook the possum's upside-down smile for a frown and resolved to rescue
 him, turning the possum's world topsy-turvy.
Identifiers: LCCN 2015029472| ISBN 9780486800806 (paperback) | ISBN
 0486800806 (paperback)
Subjects: | CYAC: Opossums—Fiction. | Identity—Fiction. | BISAC: ART /
 General. | JUVENILE FICTION / Humorous Stories.

Classification: LCC PZ7.T21114 Po 2016 | DDC [Fic]—dc23 LC record available
at http://lccn.loc.gov/2015029472

Manufactured in the United States by RR Donnelley
80080601 2016
www.doverpublications.com

TO

PATRICIA ANNE

THE

LITTLE

GIRL

THAT

IS . . .

AND

DOES

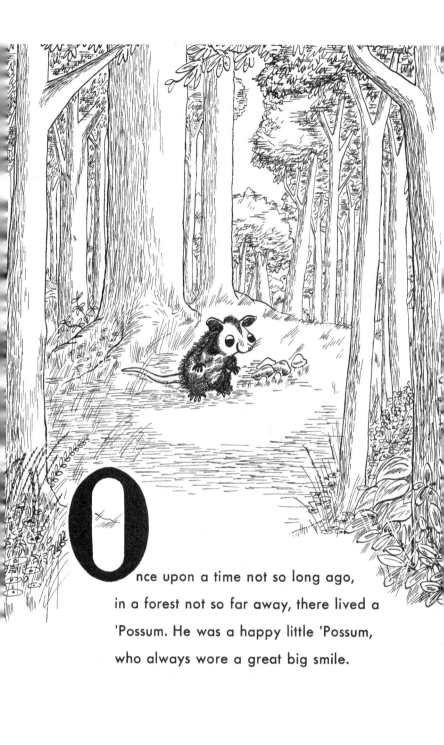

Once upon a time not so long ago, in a forest not so far away, there lived a 'Possum. He was a happy little 'Possum, who always wore a great big smile.

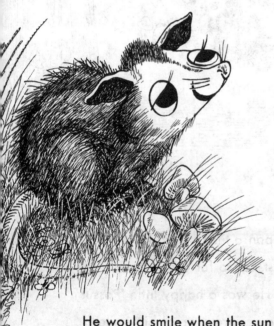

He would smile when the sun was shining.

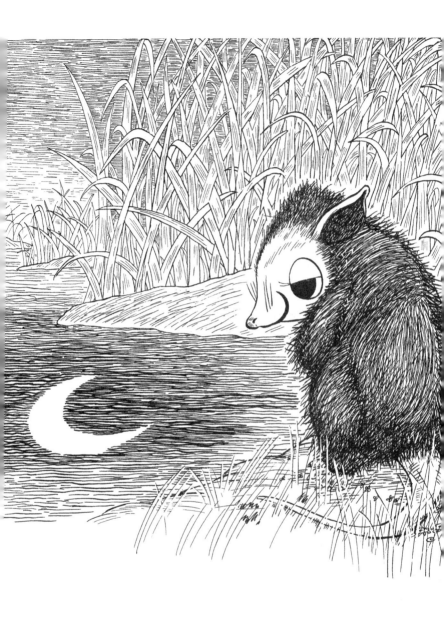

He would smile when the moon was shining.

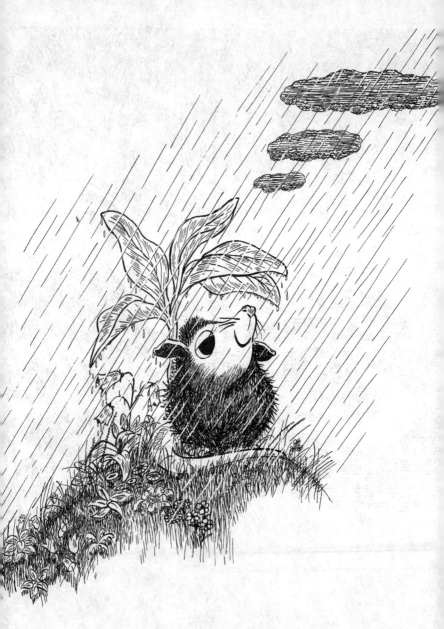

He would smile when nothing was shining.

He

would

smile

too,

as he

climbed

up a

tall

tree,

that had

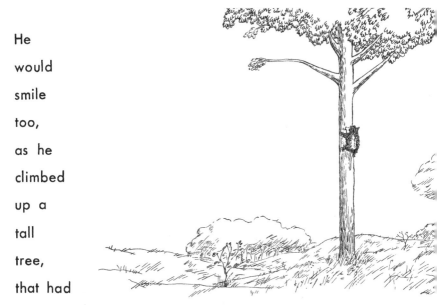

a long overhanging branch. When he reached the branch,

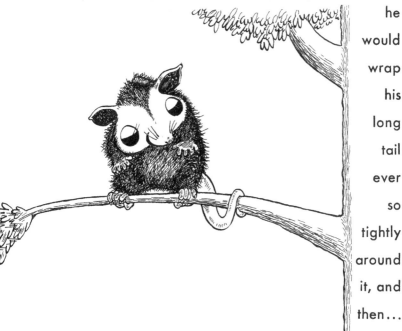

he

would

wrap

his

long

tail

ever

so

tightly

around

it, and

then...

...he would hang upside down by his tail, just like all 'Possums do. He would hang like this for days, just smiling and smiling and then smiling some more. He was the happiest, smilingest, hangingest 'Possum in the whole forest.

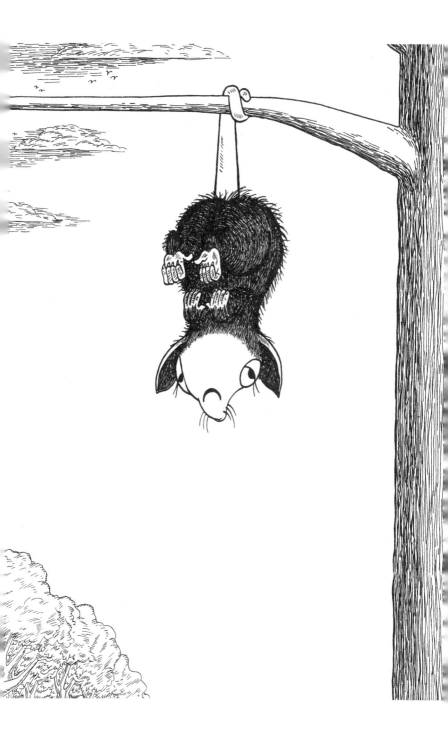

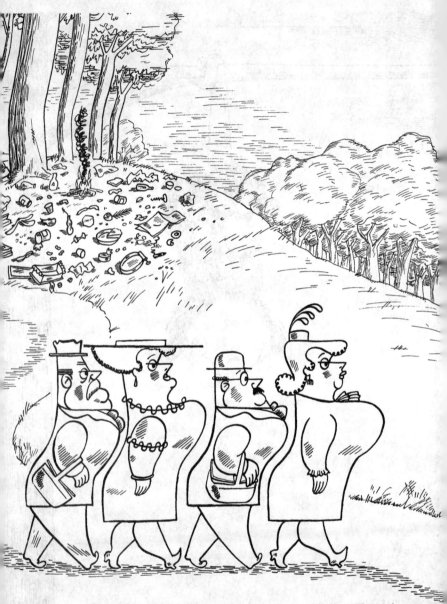

One day some people approached the tree. They had been
on a picnic and were on their way back to the city.

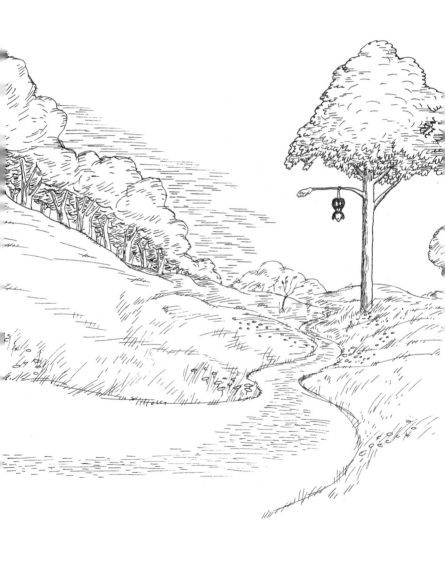

"Oh, dear me," one of the women said. "Look at that 'Possum hanging there, doesn't he look unhappy?" The 'Possum answered, "I'm not unhappy, in fact I am very happy. That's why I'm smiling."

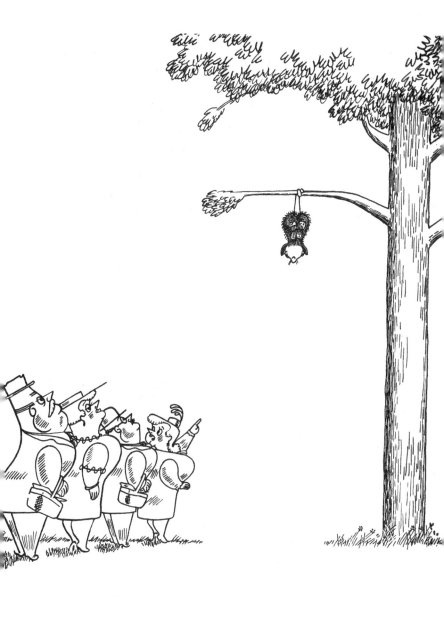

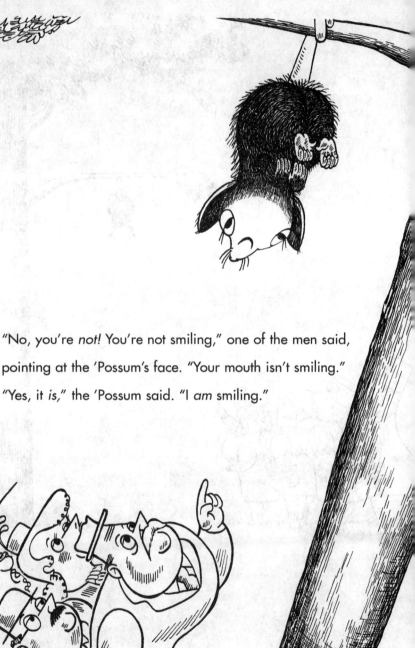

"No, you're *not!* You're not smiling," one of the men said,

pointing at the 'Possum's face. "Your mouth isn't smiling."

"Yes, it *is*," the 'Possum said. "I *am* smiling."

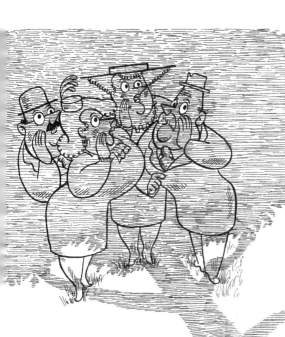

The people moved away from the tree and whispered. "He isn't smiling!" the man said. "Any one can see that the corners of his mouth turn *down* instead of *up*." The other man said, "He's just a stupid 'Possum who thinks he's smiling when he isn't!"

"But I feel sorry for him," one of the women said. "He looks so unhappy. Let's take him to the city. *That* will make him happy and then he will smile."

" 'Possum," the man said, "we have decided
to do something very nice for you."
"Thank you," the 'Possum answered. "You're
very kind." "Come down from that tree,"
the man said. "We are going to take you
to the city to make you smile and be happy."
"Oh, please don't bother," the 'Possum said.
"I'm happy here where I am and I know
I'm smiling. So you must be mistaken."

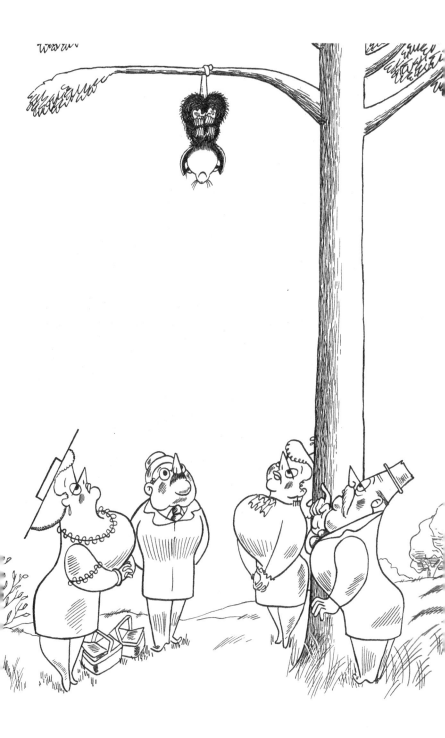

"How dare
you say
that we are
mistaken!"
the man
shouted,
angrily.
"You're not
a smiley,
smiley
'Possum!
You're a
stupidly,
stupidly
'Possum,
who thinks
he's smiling
when he isn't!"
The 'Possum
said,
"But I *am* smiling."

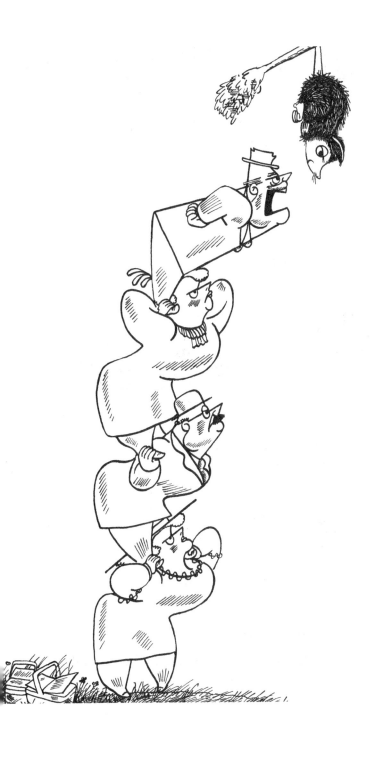

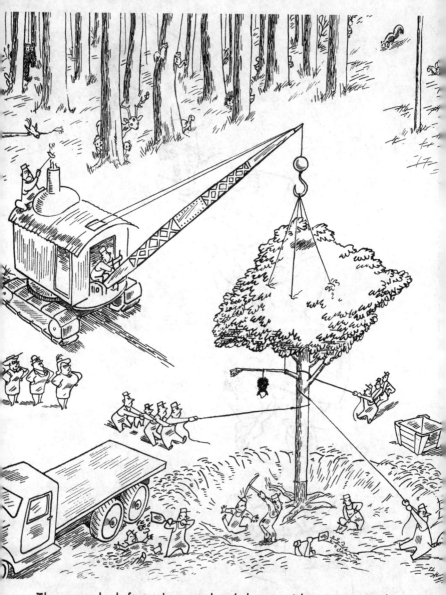

The people left and came back later with more people.

They took the 'Possum's tree right out of the ground...

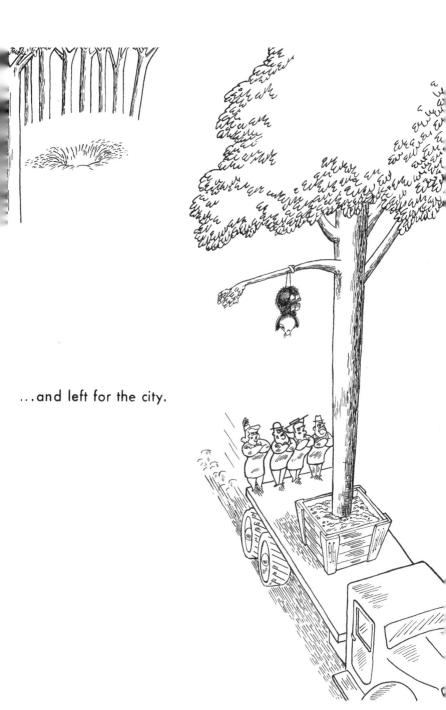

...and left for the city.

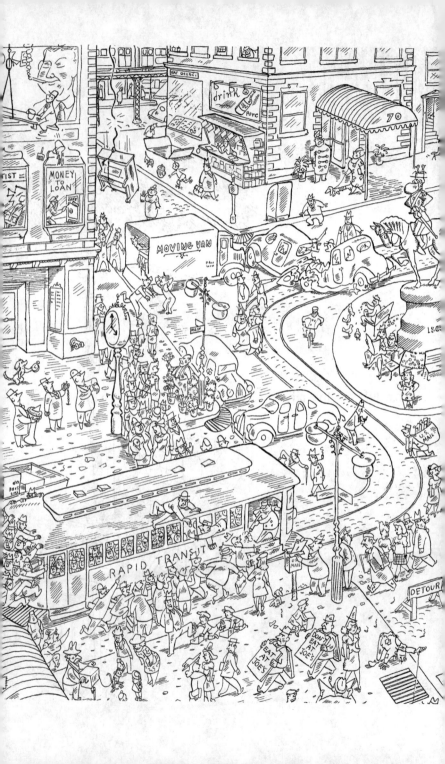

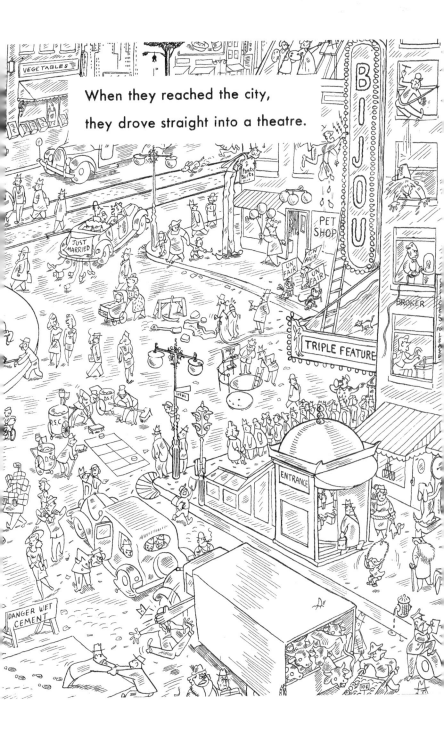

When they reached the city,
they drove straight into a theatre.

"We are taking you to see a *movie*," the man said. "*Everyone* smiles when they see a movie and *you* will smile, too." "But I *am* smiling," the 'Possum said. "You're not a smiley, smiley 'Possum!" the people told him. "You're a stupidly, stupidly 'Possum, who thinks he's smiling when he isn't."

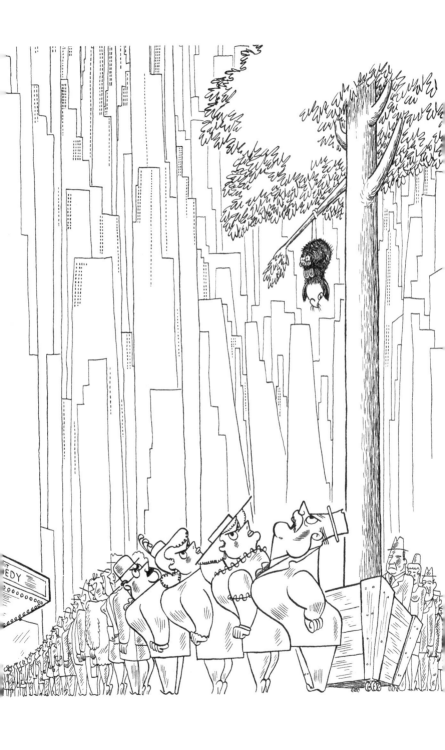

So they took him into the movie.

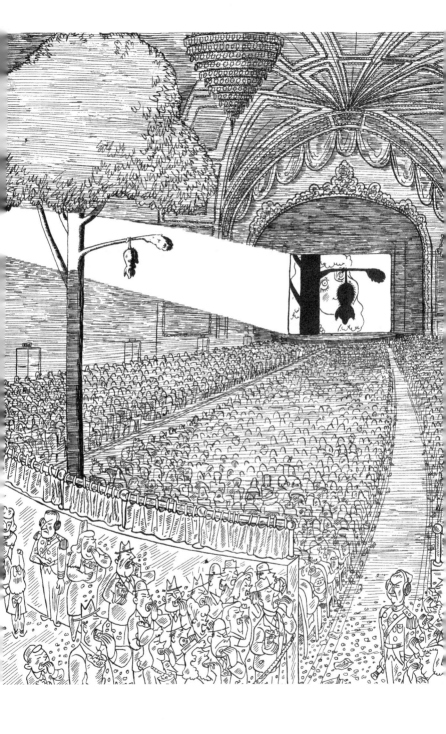

After the movie was over, the
people looked up at the 'Possum.
"He *still* isn't smiling," they said.
"I enjoyed the movie," the 'Possum said. "I thought
the story was very good and I *am* smiling." "You're
not a smiley, smiley 'Possum!" the people told him. "You're a
stupidly, stupidly 'Possum, who thinks he's smiling when he isn't."
Then, the man said, "We will take you to a night club. *Everyone*
smiles when they go to a night club and *you* will smile, too."

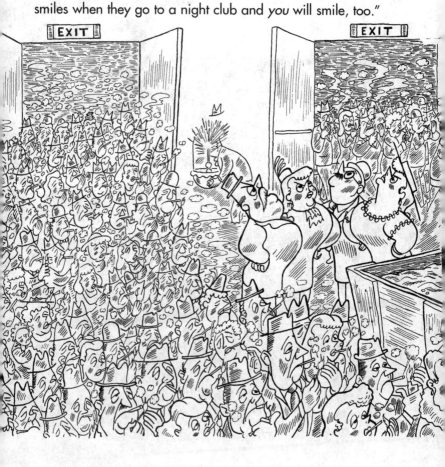

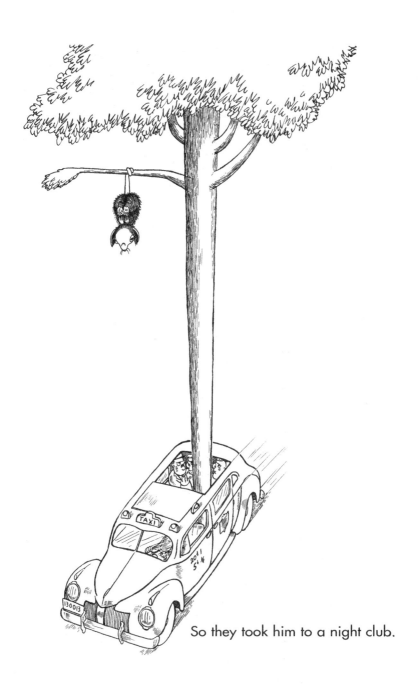

So they took him to a night club.

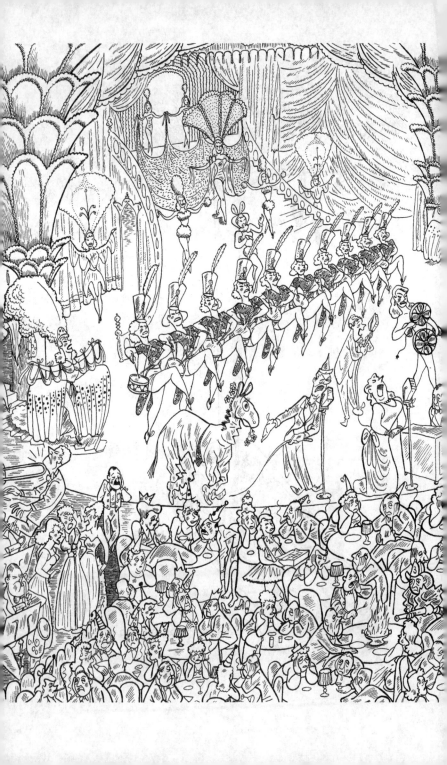

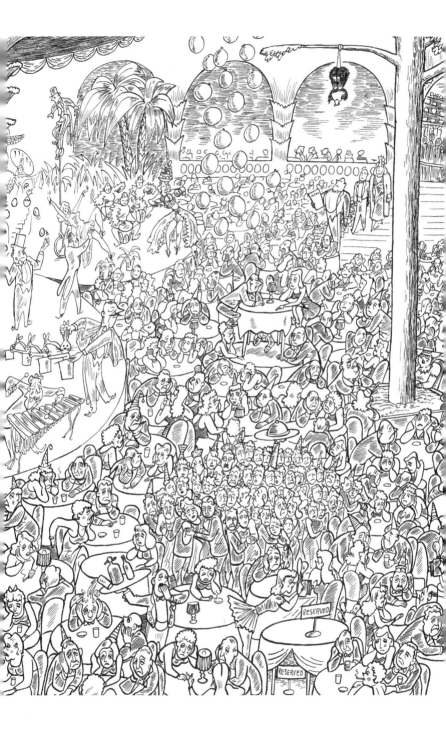

After they left the night
club, the people looked up
at the 'Possum.
"He *still* isn't smiling,"
they said.
Now, they became furious and
walked around the tree,
shaking their fists at the 'Possum. "Stupidly,
stupidly 'Possum!" they shouted.
"We are going to make you smile,
if it takes forever!"
The 'Possum just hung there.
He didn't say anything.

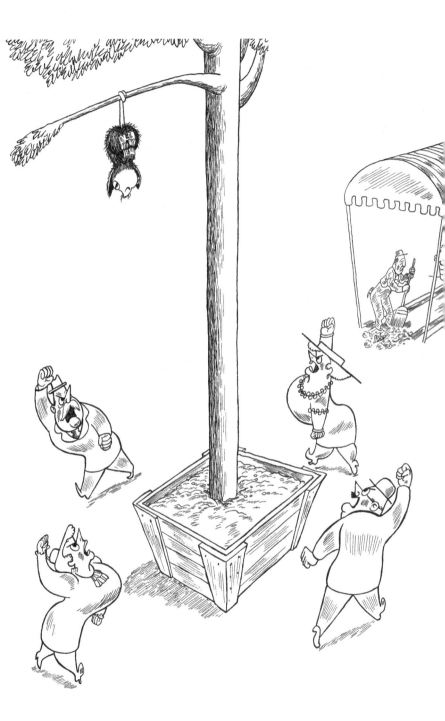

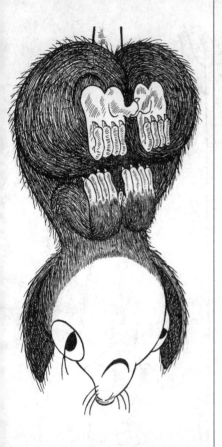

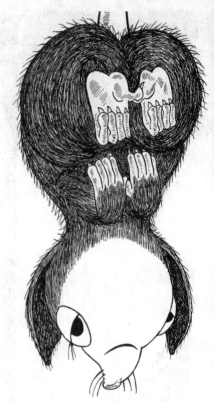

He looked down at the people below and he thought about them. He thought about *all* the people he had seen in the city.

The more he thought about them, the sadder . . .

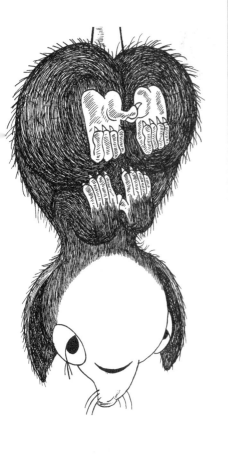

. . . and *sadder* he became.

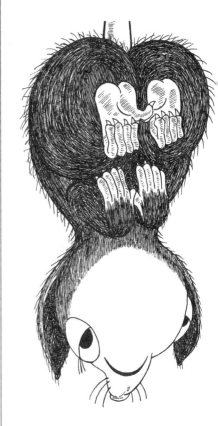

Until he was *very sad*.

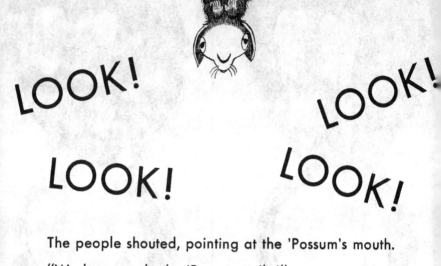

LOOK! LOOK!

LOOK! LOOK!

The people shouted, pointing at the 'Possum's mouth.

"We have made the 'Possum smile!"

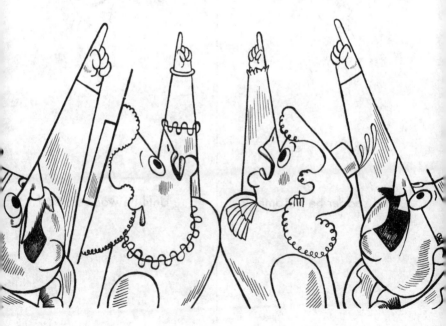

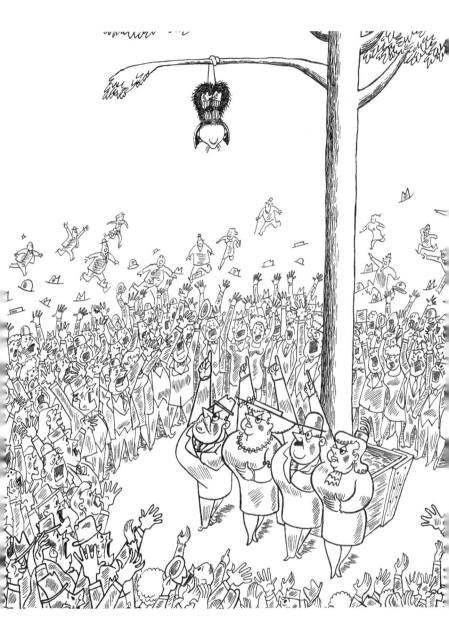

Crowds came running from all directions. They cheered and cheered the people, who had made the 'Possum smile.

DAILY NEWS

They had their pictures in all the papers, because
they had made the 'Possum smile.

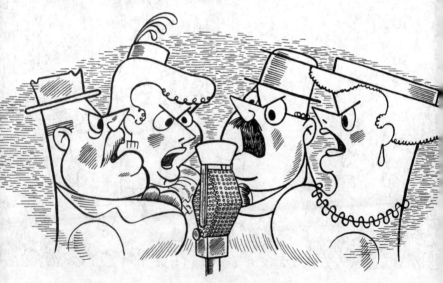

They spoke over the radio and told everyone how
they had made the 'Possum smile.

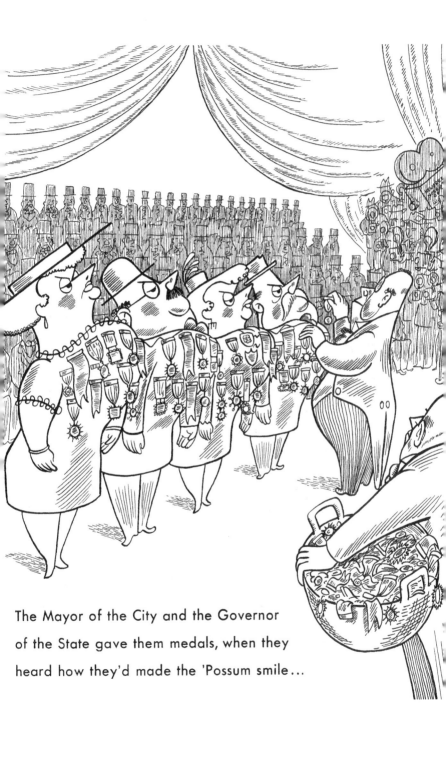

The Mayor of the City and the Governor
of the State gave them medals, when they
heard how they'd made the 'Possum smile...

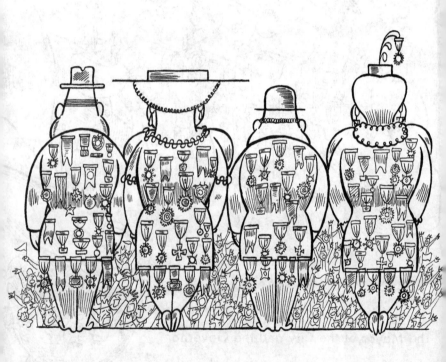

. . . lots of medals.

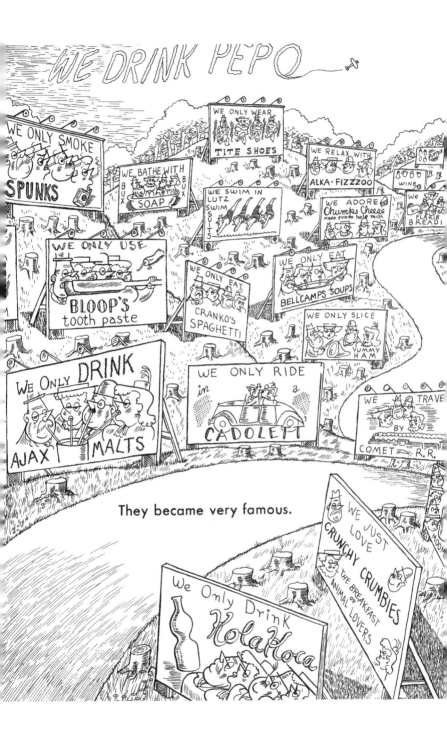

They became very famous.

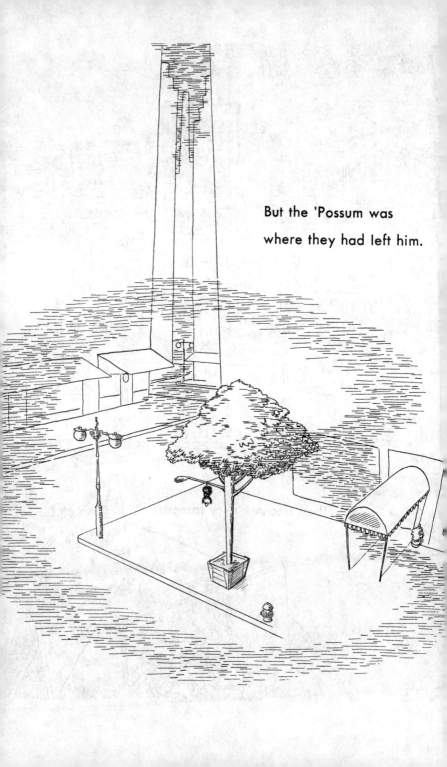

But the 'Possum was
where they had left him.

Sadly, he climbed down from his tall tree and started walking back to the forest. As he crossed the wide street, he heard music in the distance.

It was a big parade in honor of the people,
who had made the 'Possum smile.

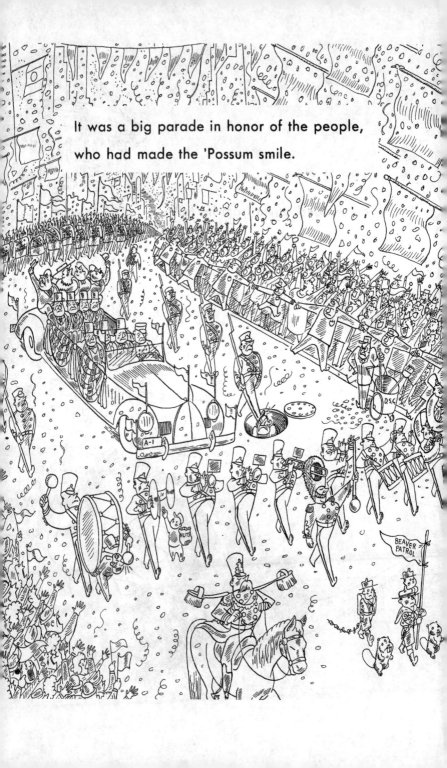

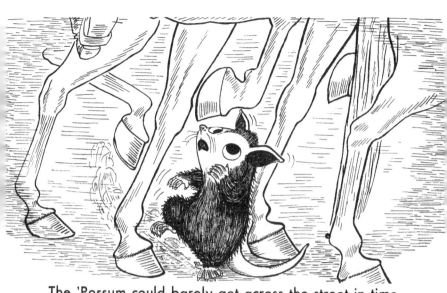

The 'Possum could barely get across the street in time.

The horses in the big parade almost trampled on him

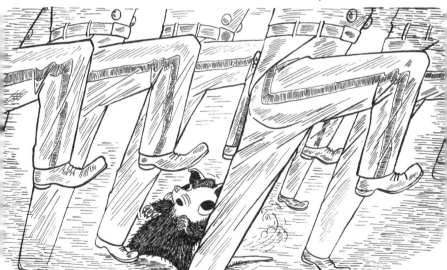

and the marching men almost stepped on him

and the big automobile almost ran
over him. He pulled his tail out from
under the wheels just in time.

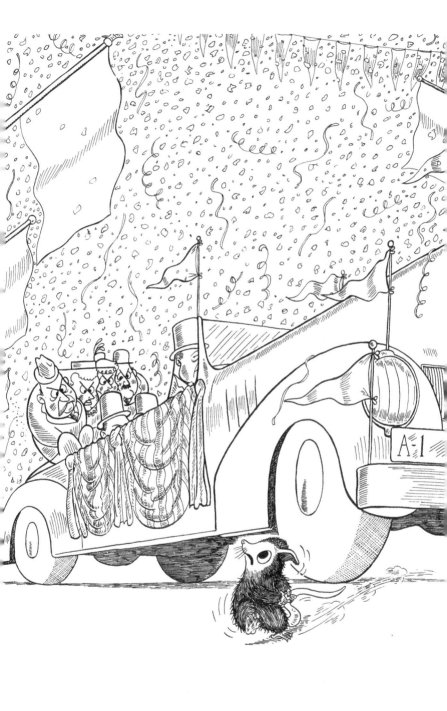

That night, the 'Possum huddled close beside a large ash can. He was still sad thinking about all the people he had seen. All night he stayed there, crying softly to himself.

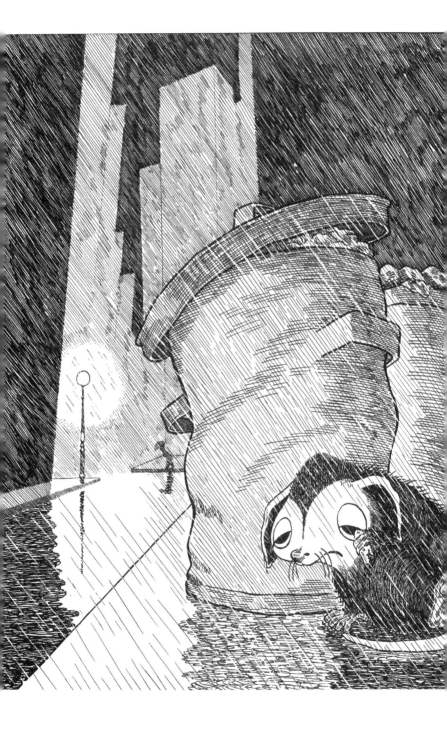

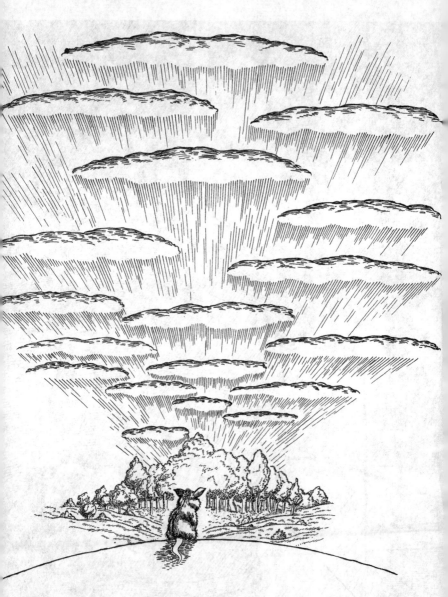

In the morning, still crying, he started home. He walked
and walked. Days later, he saw the tall trees of the forest.

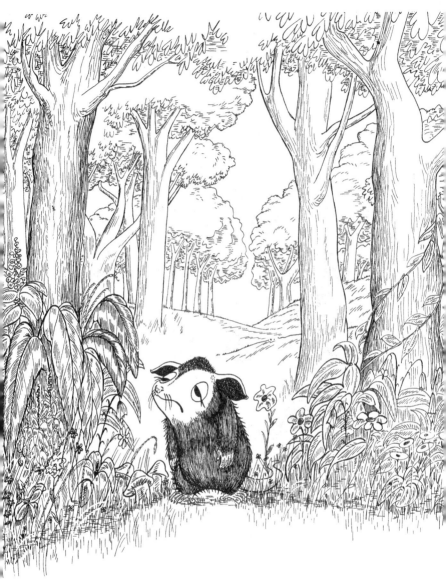

He was home.

But he was unhappy. He felt that he would never smile again.

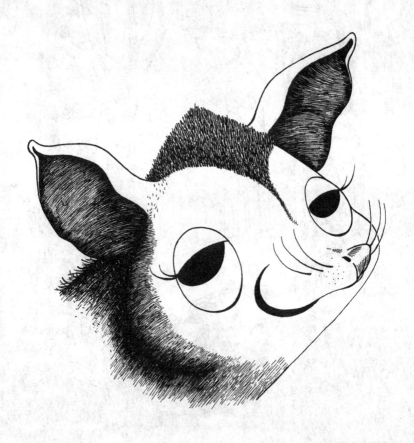

But suddenly . . . he *did* smile!

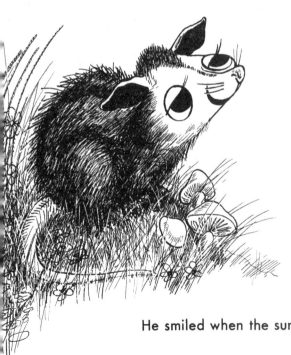

He smiled when the sun was shining!

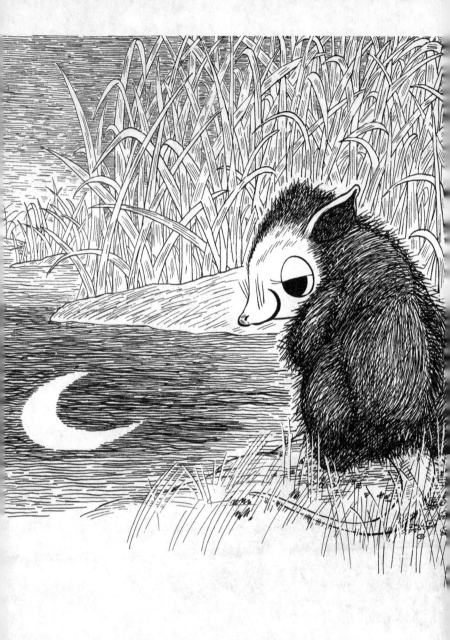

He smiled when the moon was shining!

He smiled when nothing was shining!

And for the rest of his life,
he was a smiley, smiley 'Possum,
because he knew that everything
that had happened to him,
must have been a dream.
He was *sure* it had been a dream.
For nowhere, could there *really*
be people, like the people he
had seen.

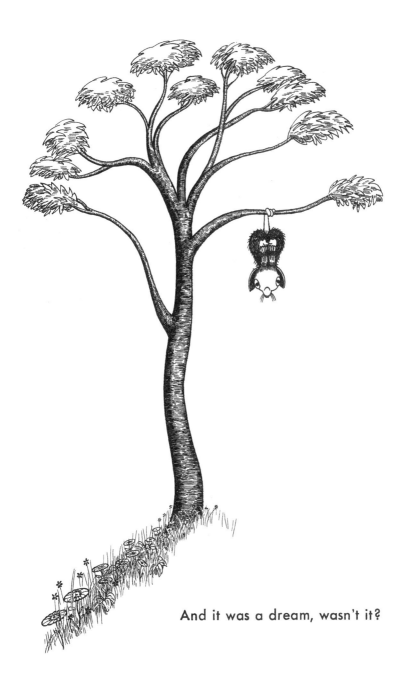

And it was a dream, wasn't it?